CHRISTMAS COLORING BOOK

FOR CHILDREN AND ADULT ENJOYMENT

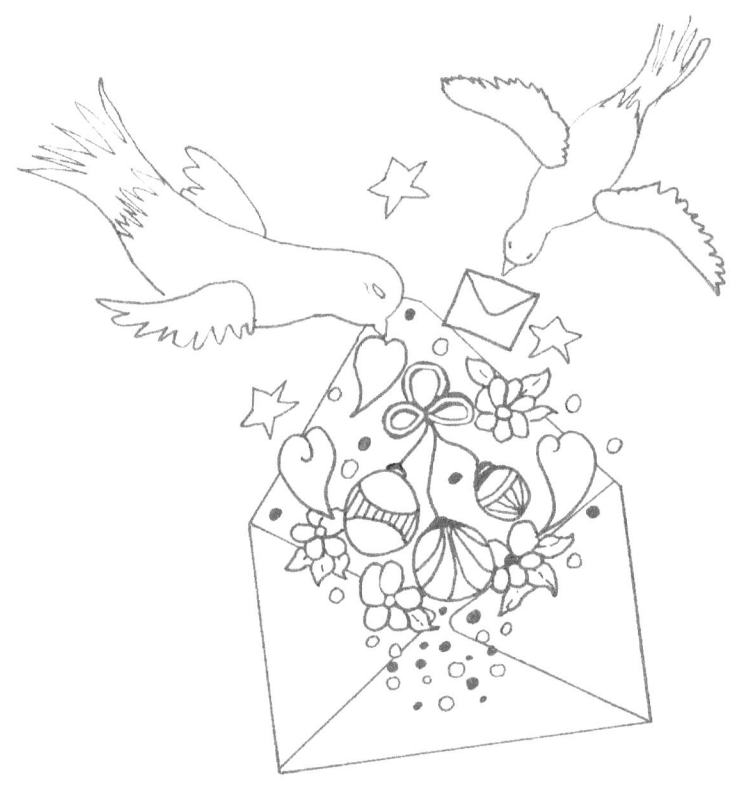

ISBN-13 978-1539170631

Copyright © 2016 Kaye Dennan

All Rights Reserved. No part of this publication may be reproduced in any form or by any means, including scanning, photocopying, or otherwise without prior written permission of the copyright holder.

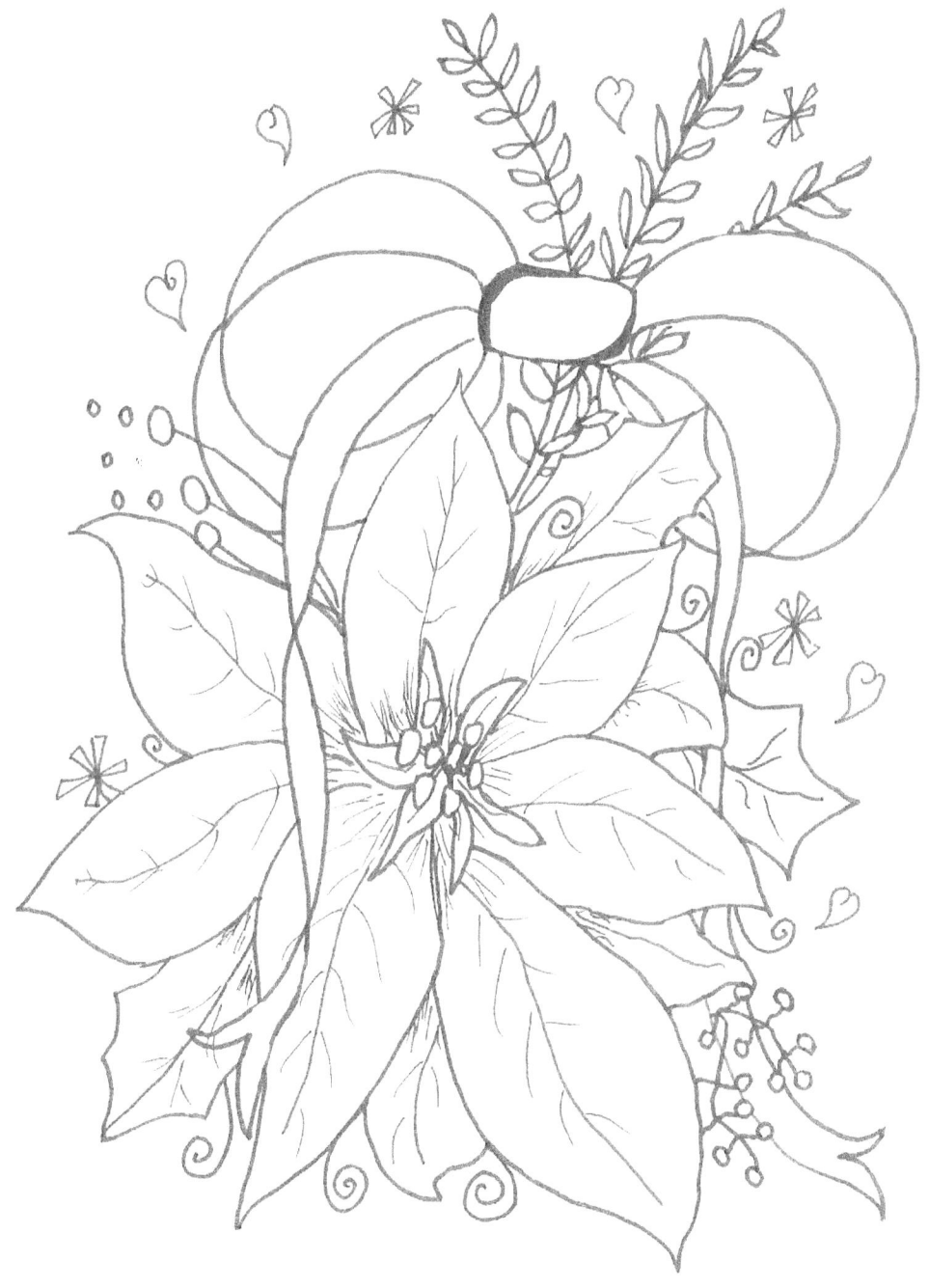

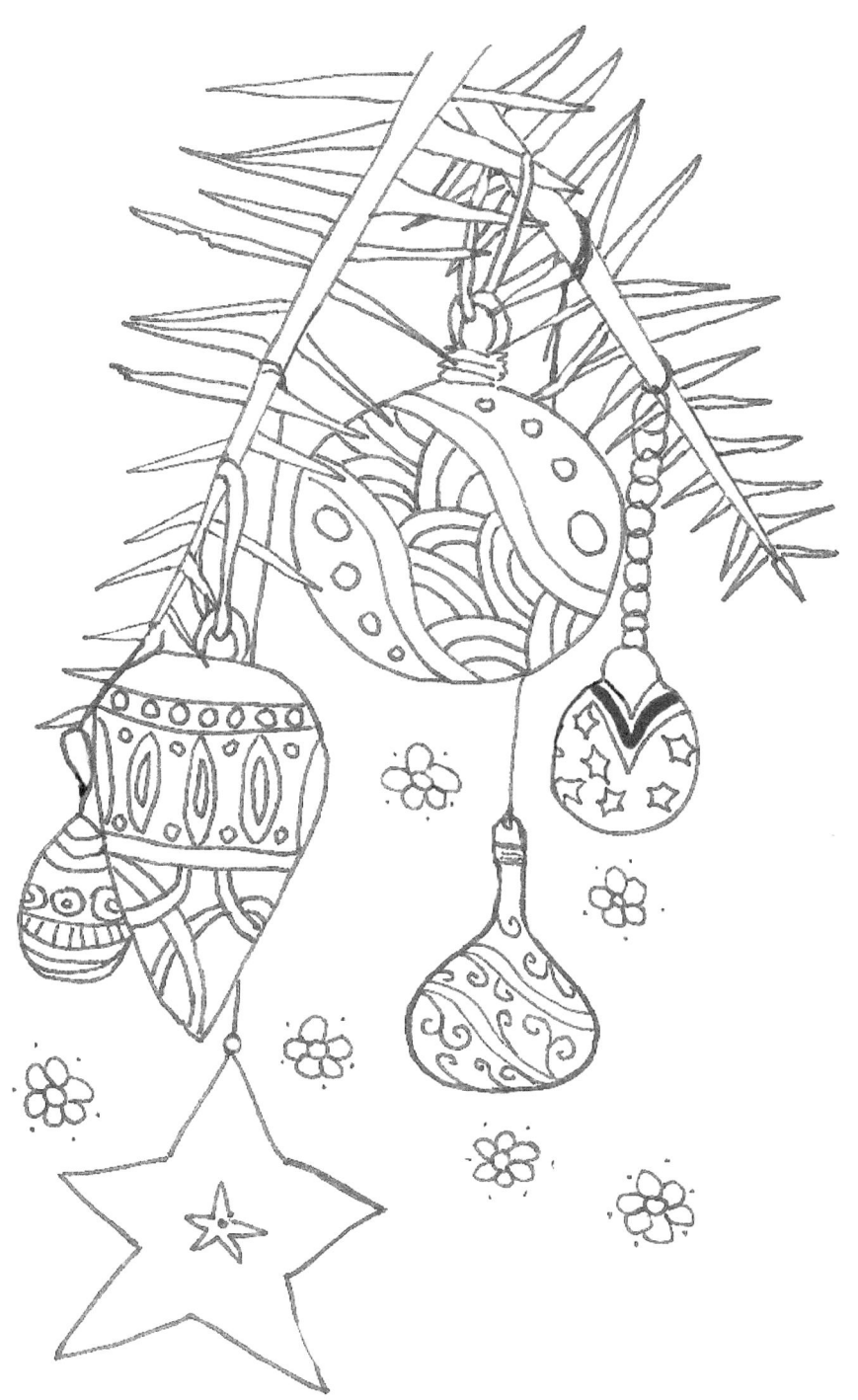

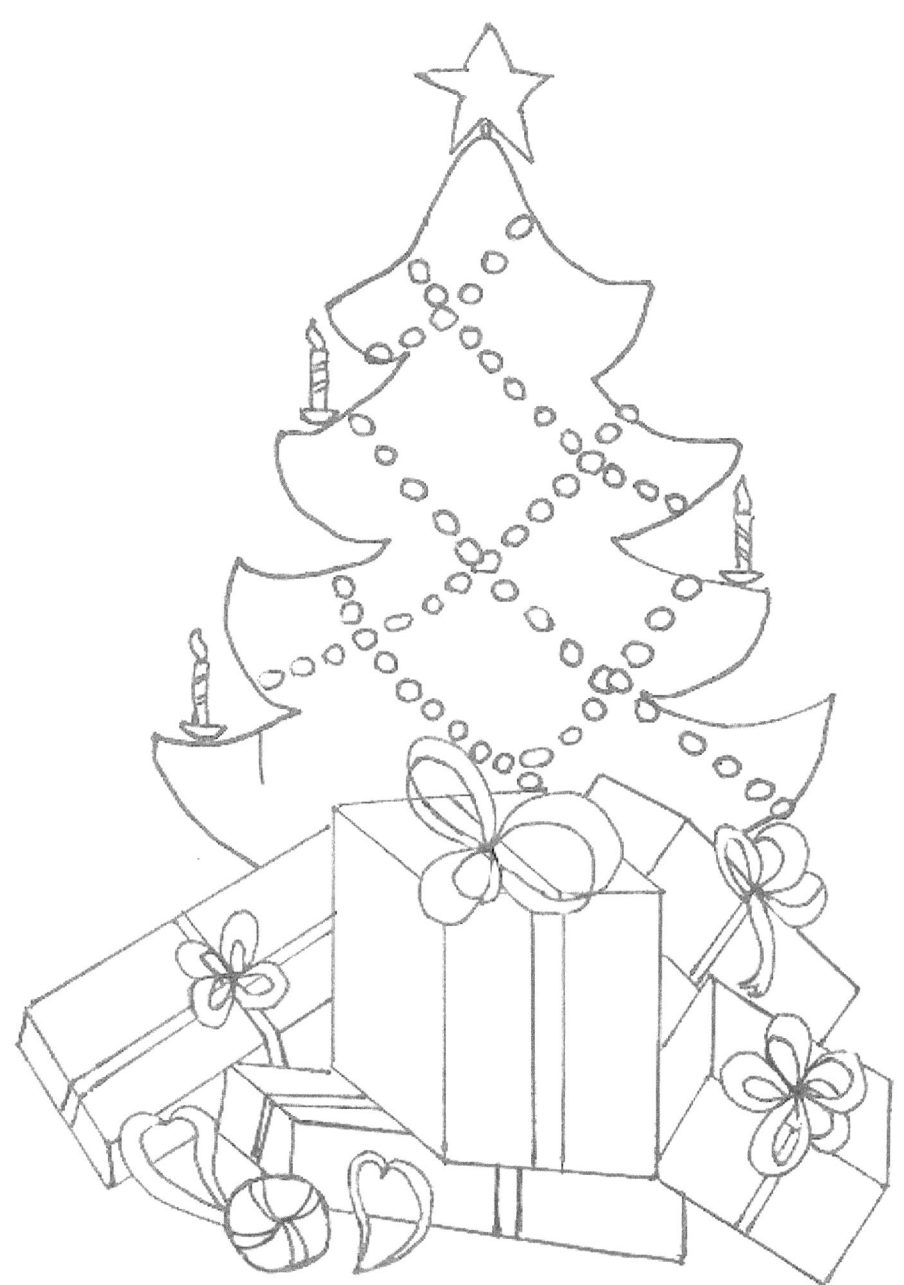

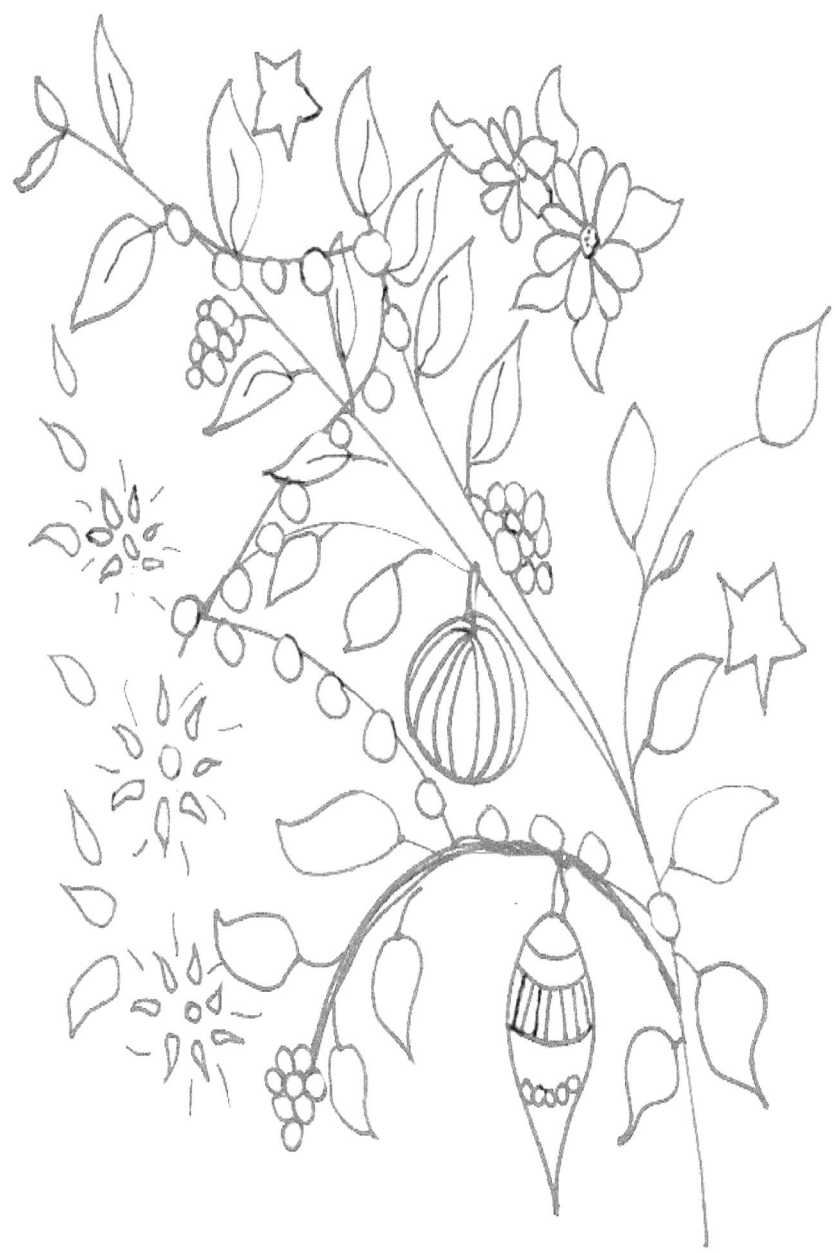

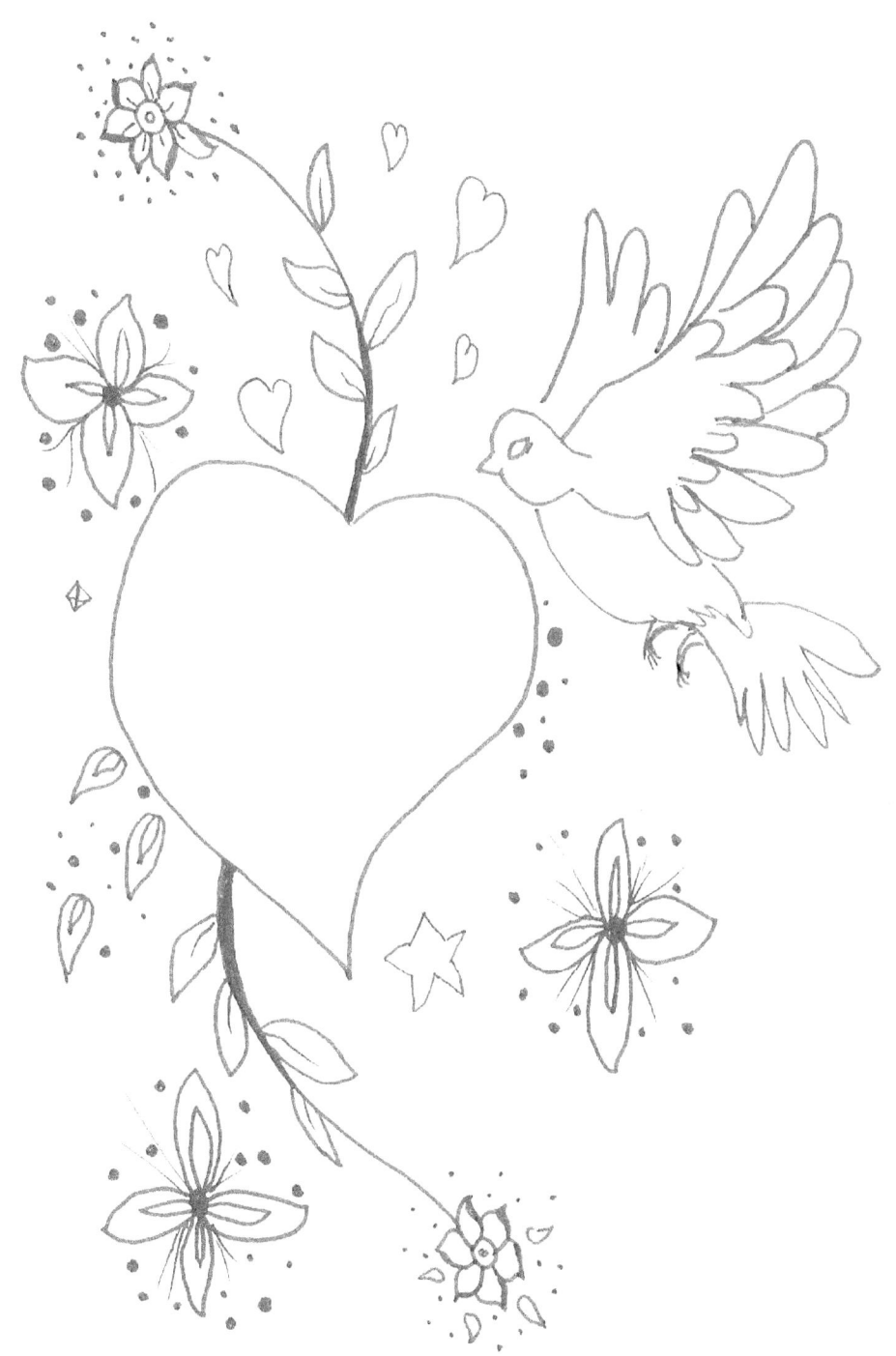

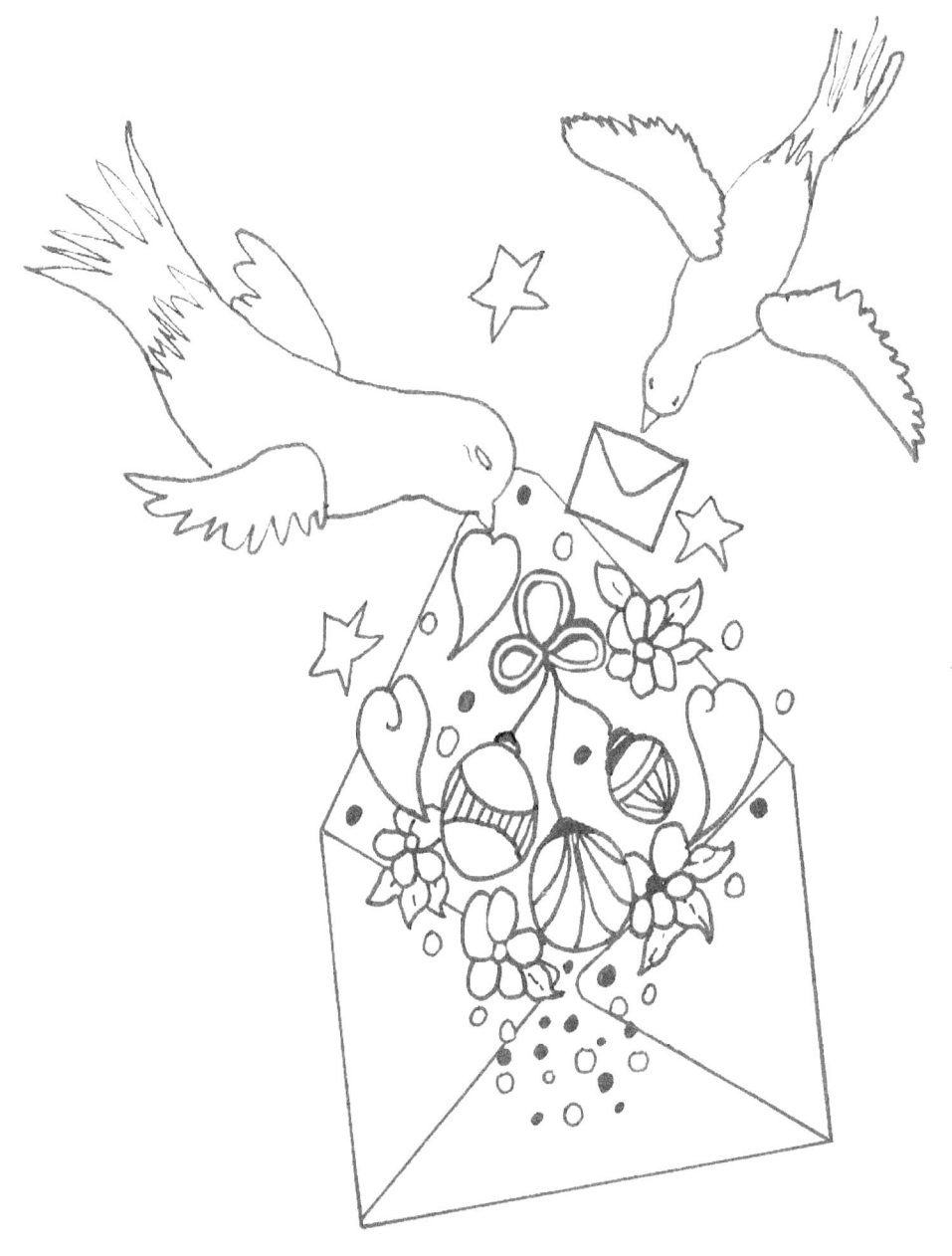

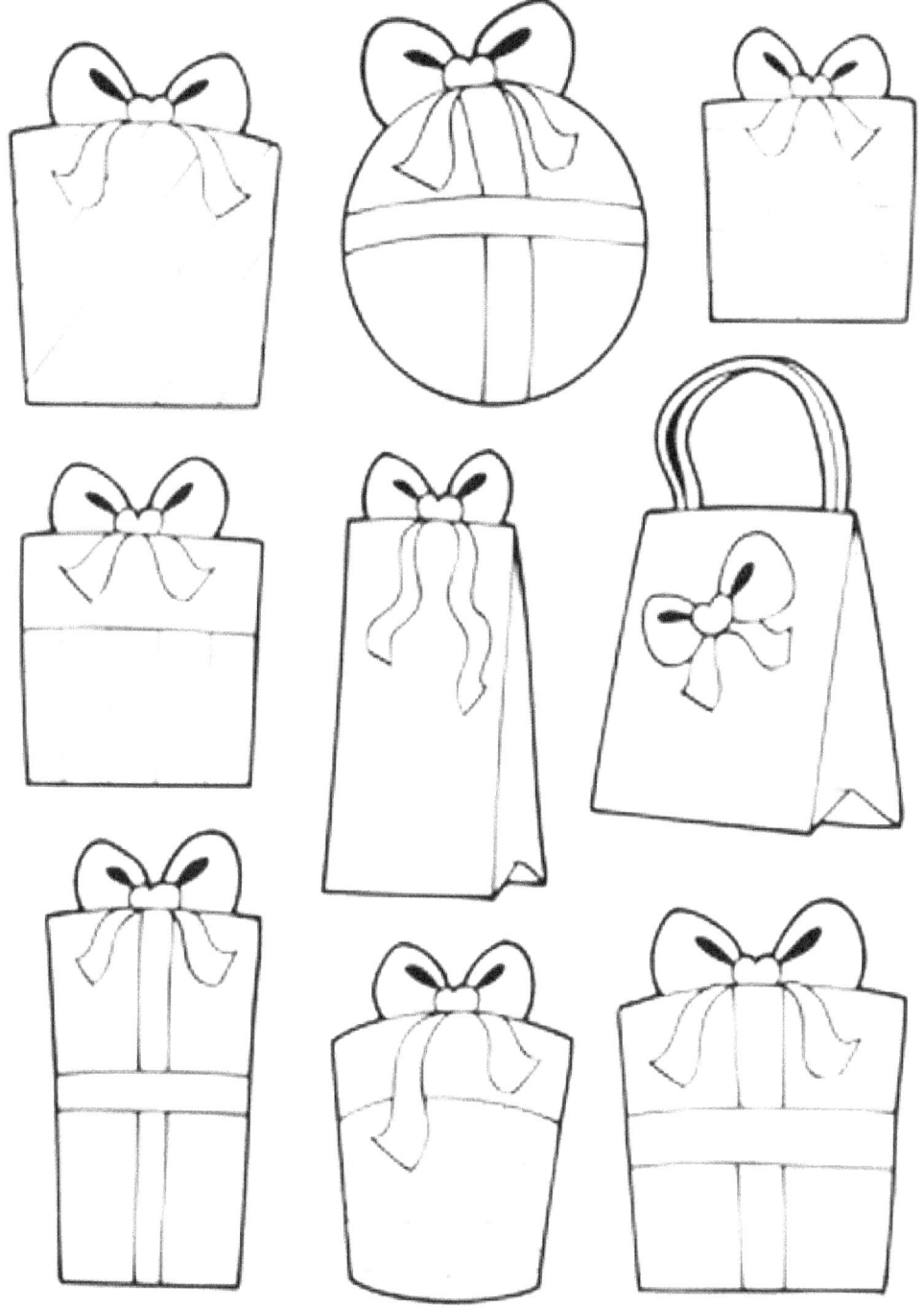

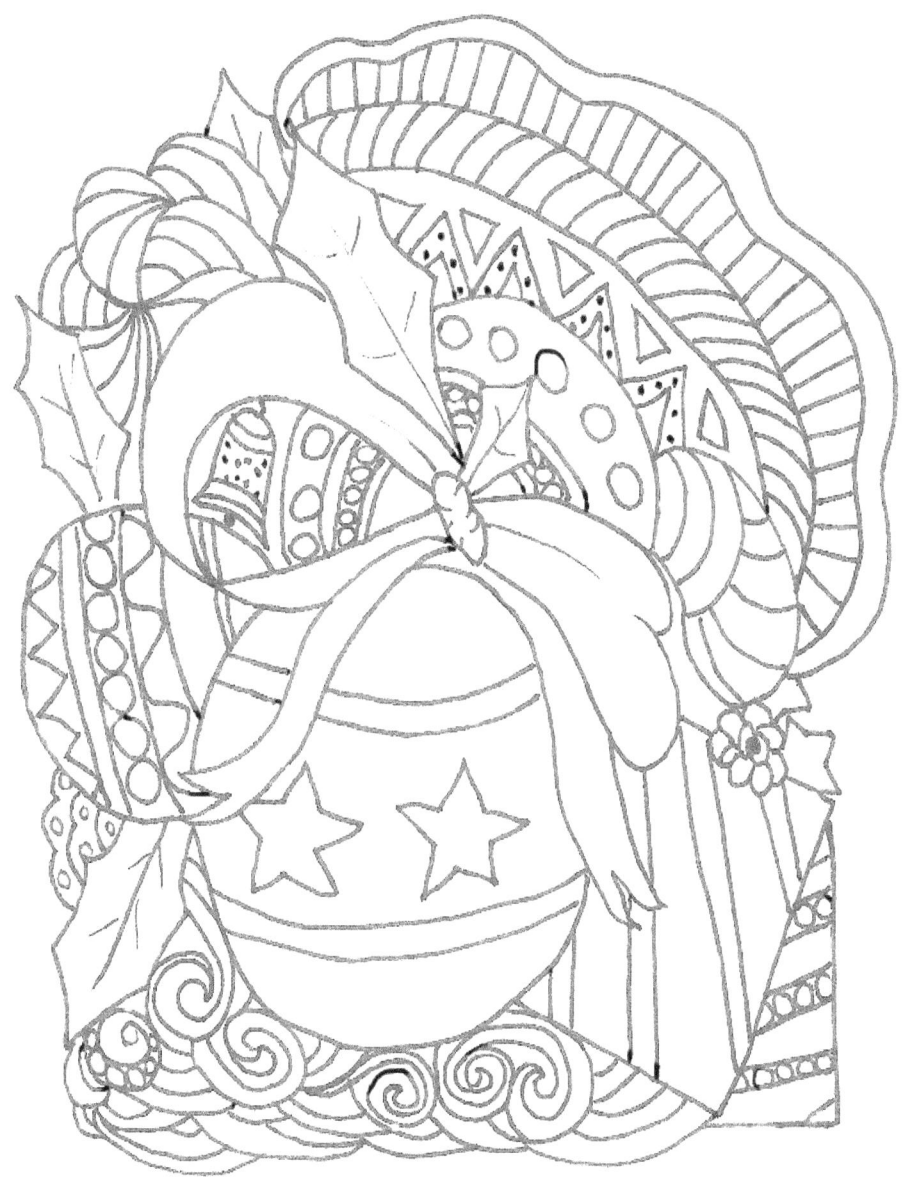

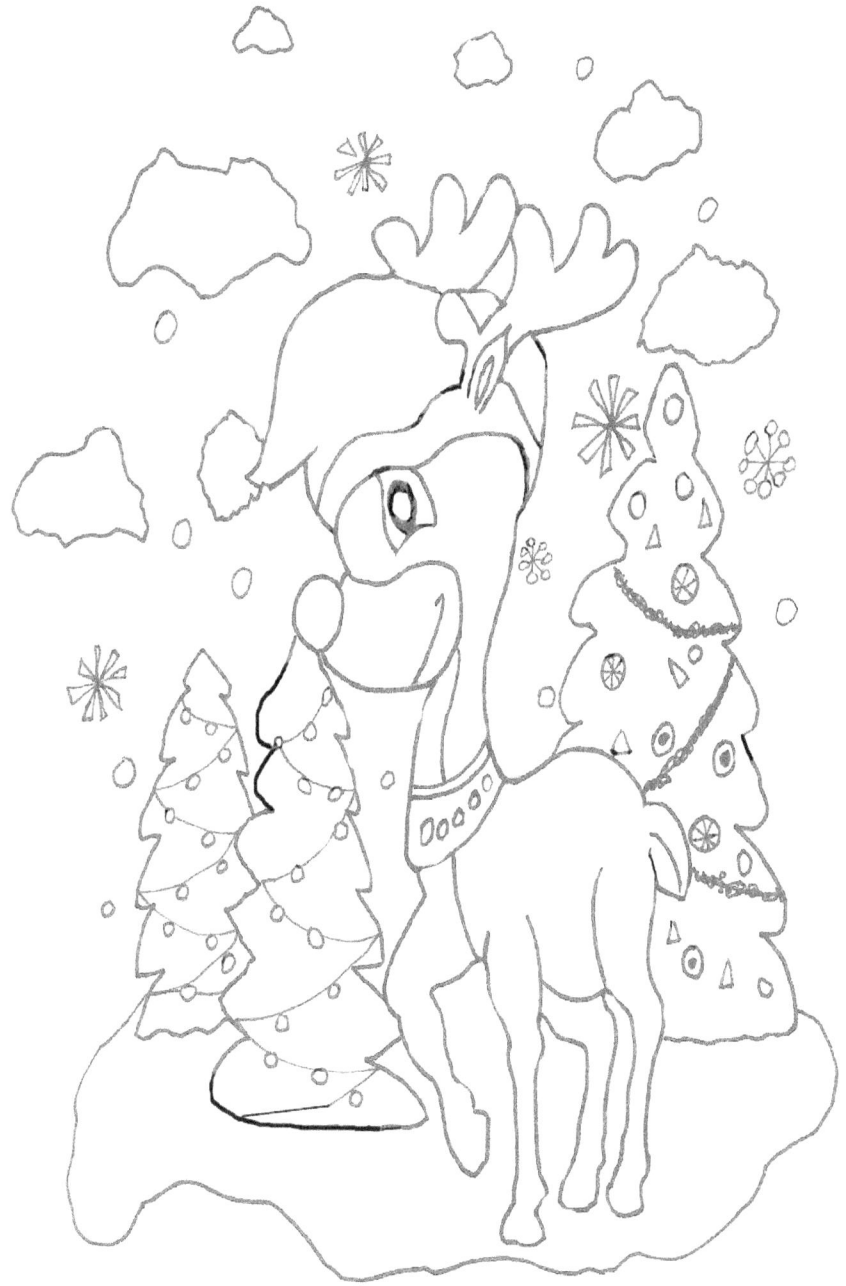

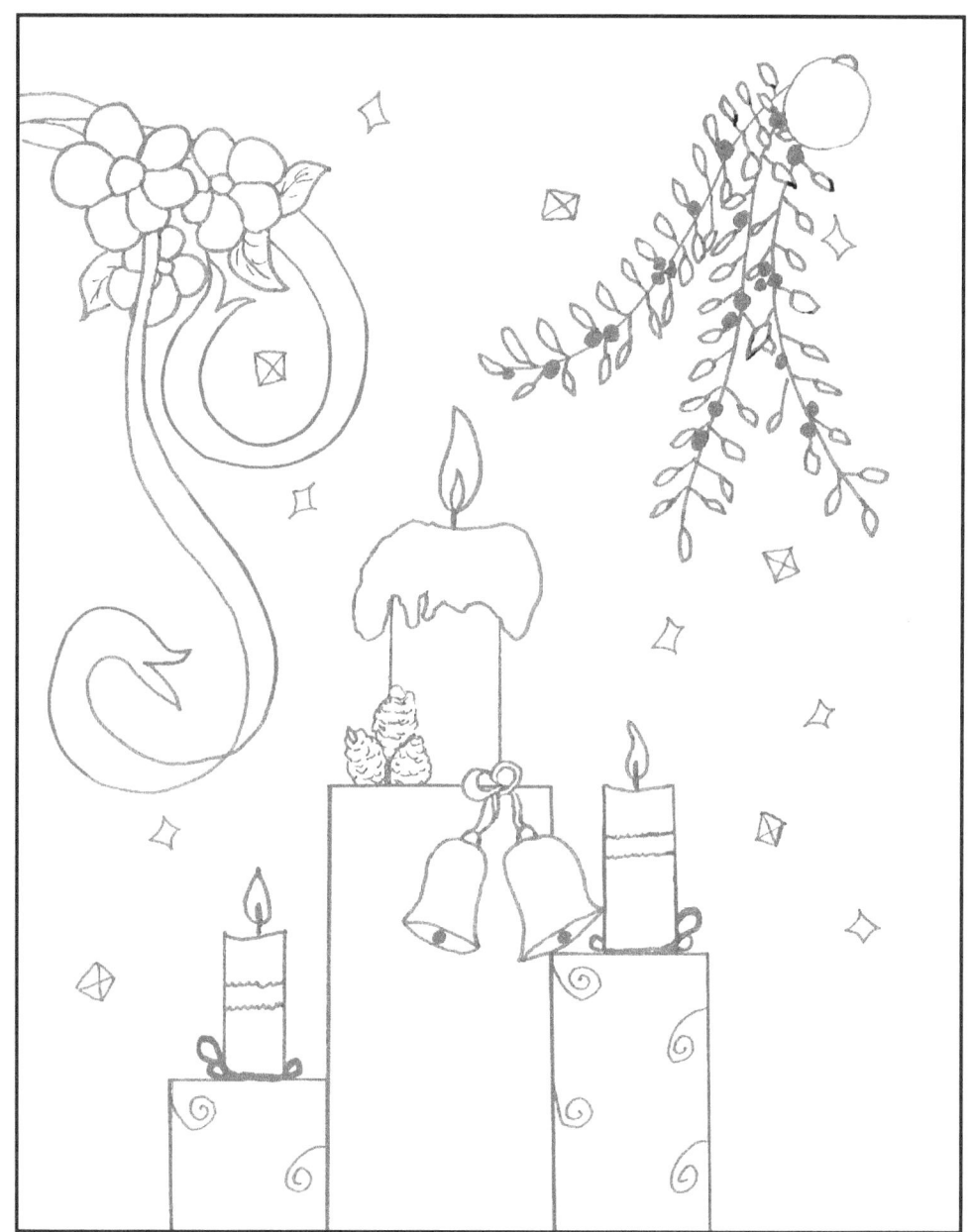

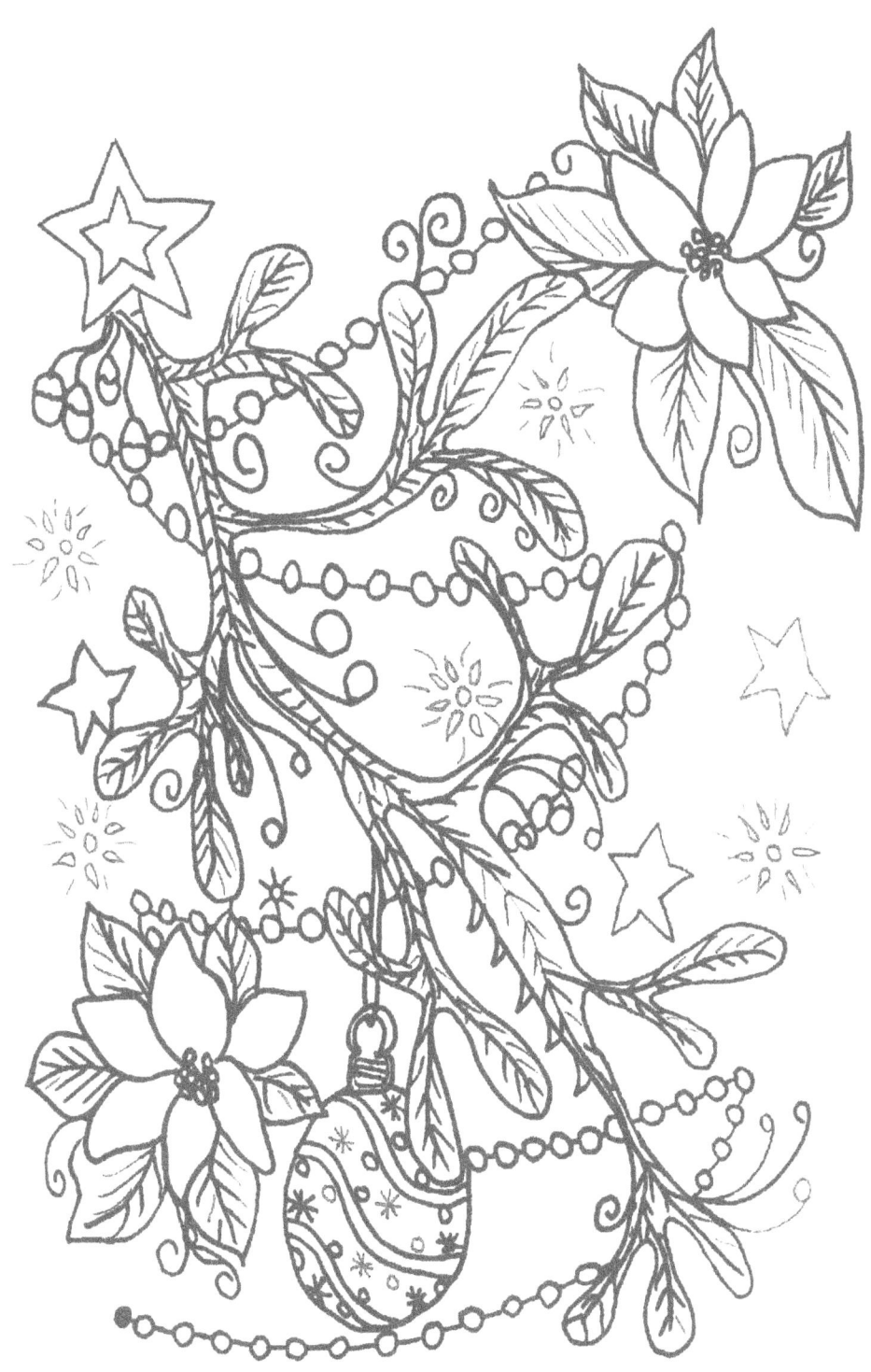

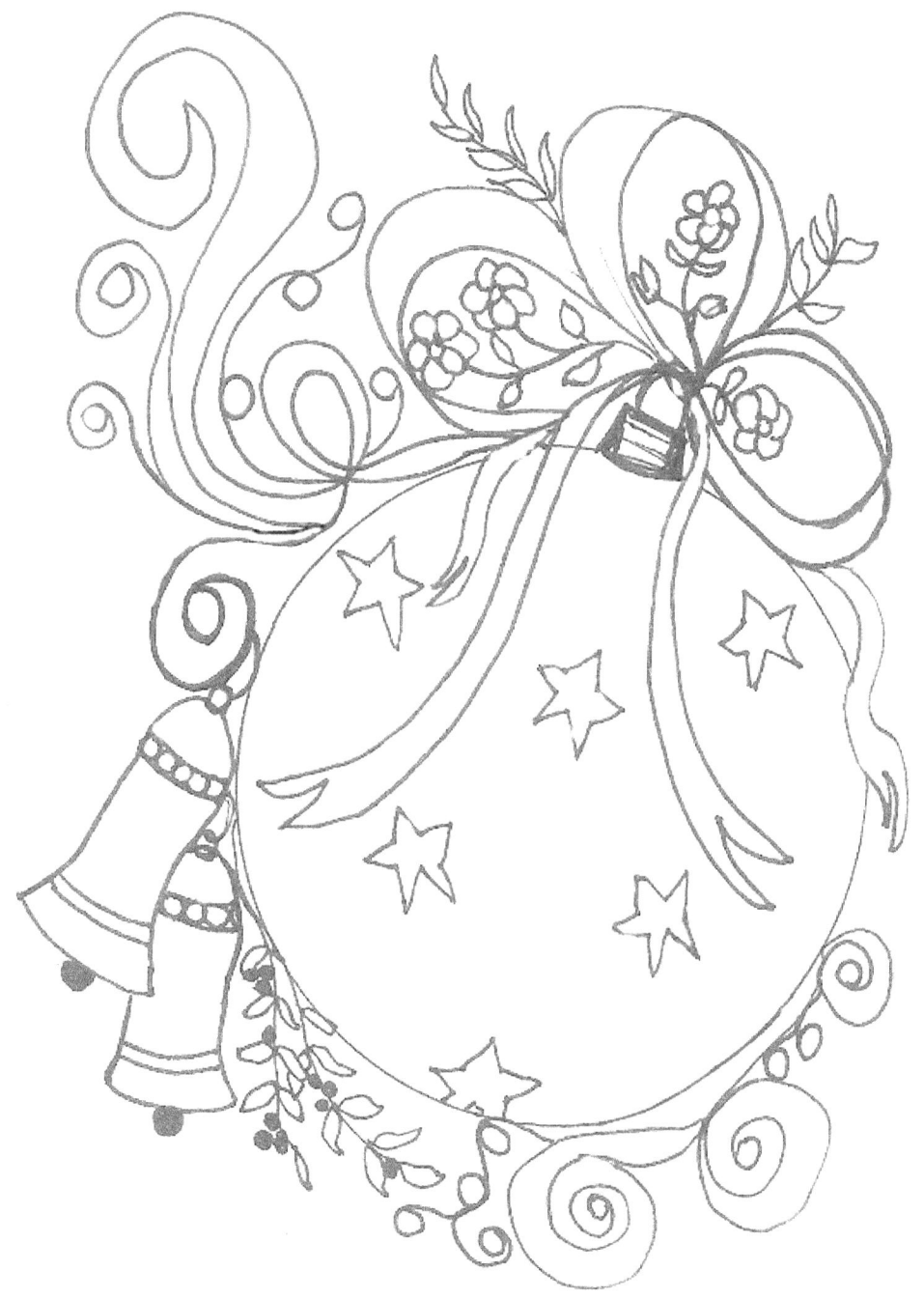

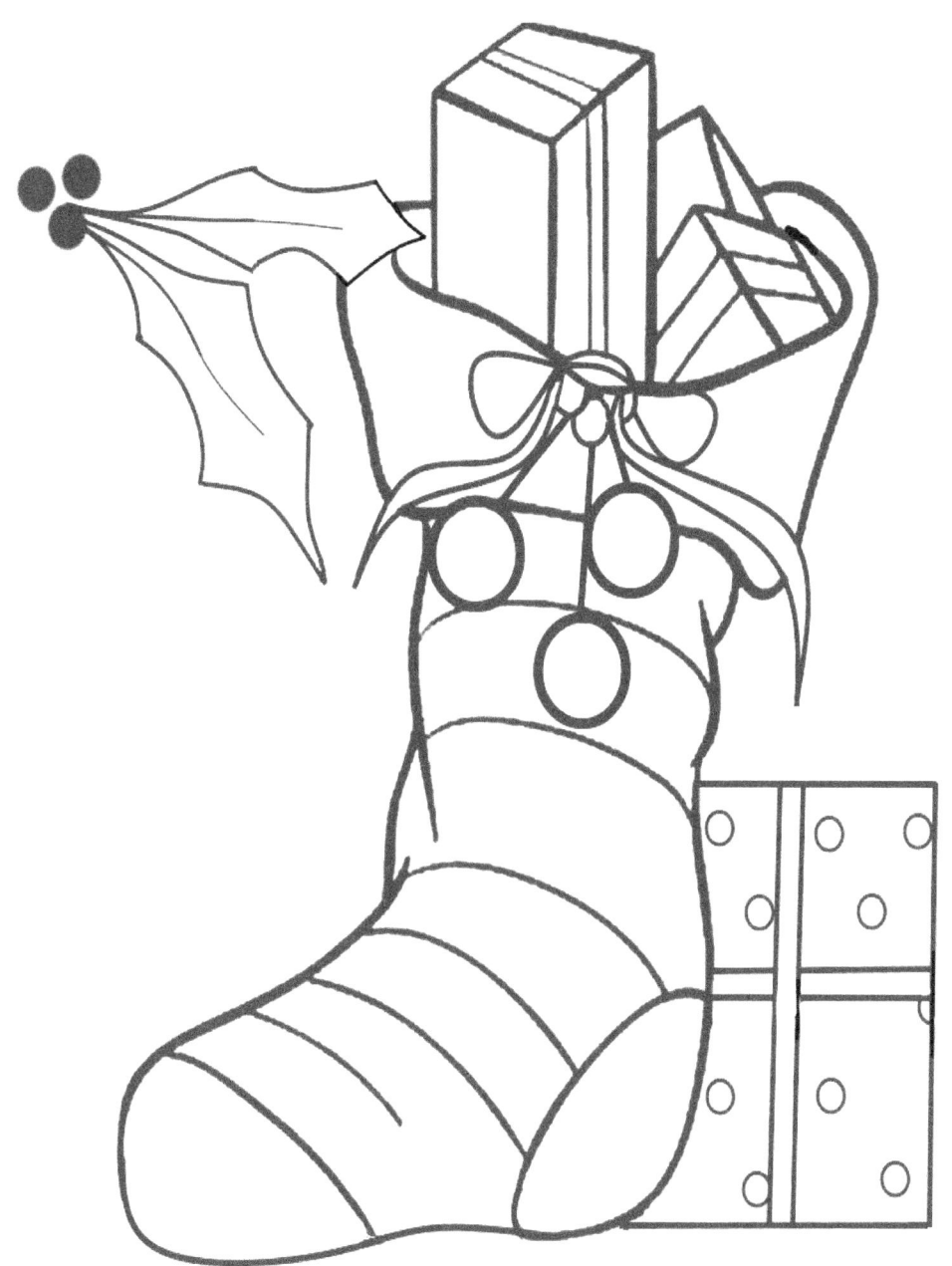

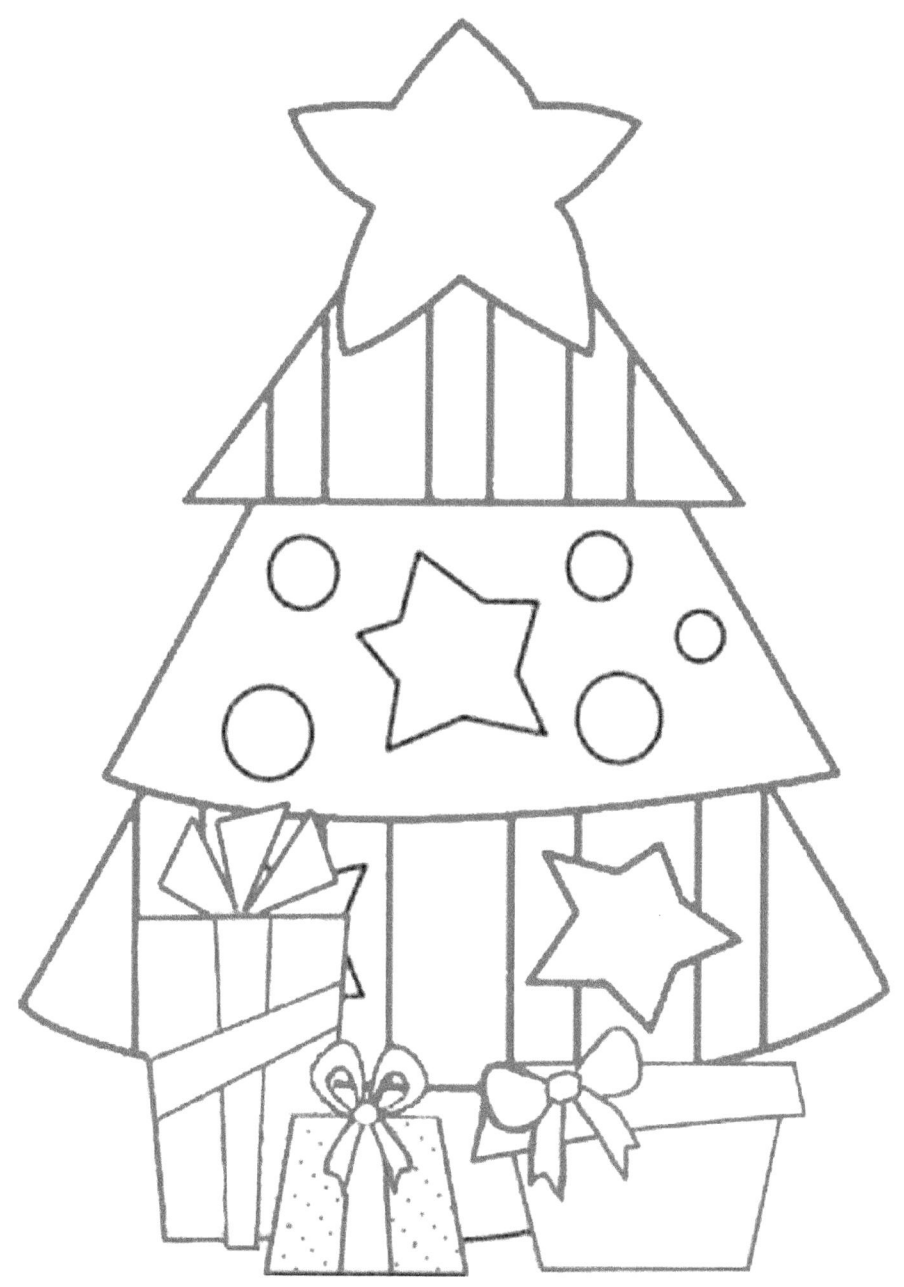

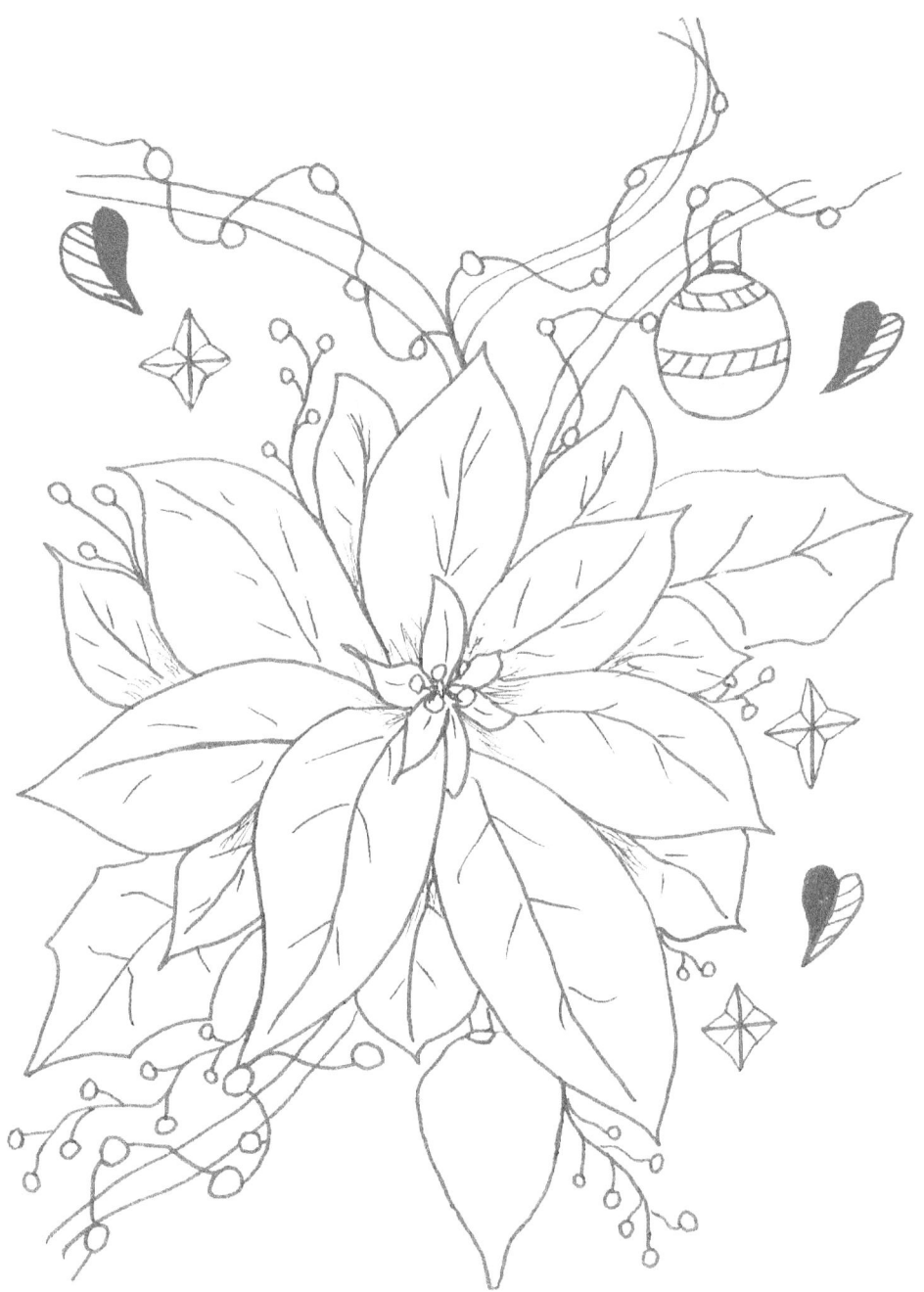

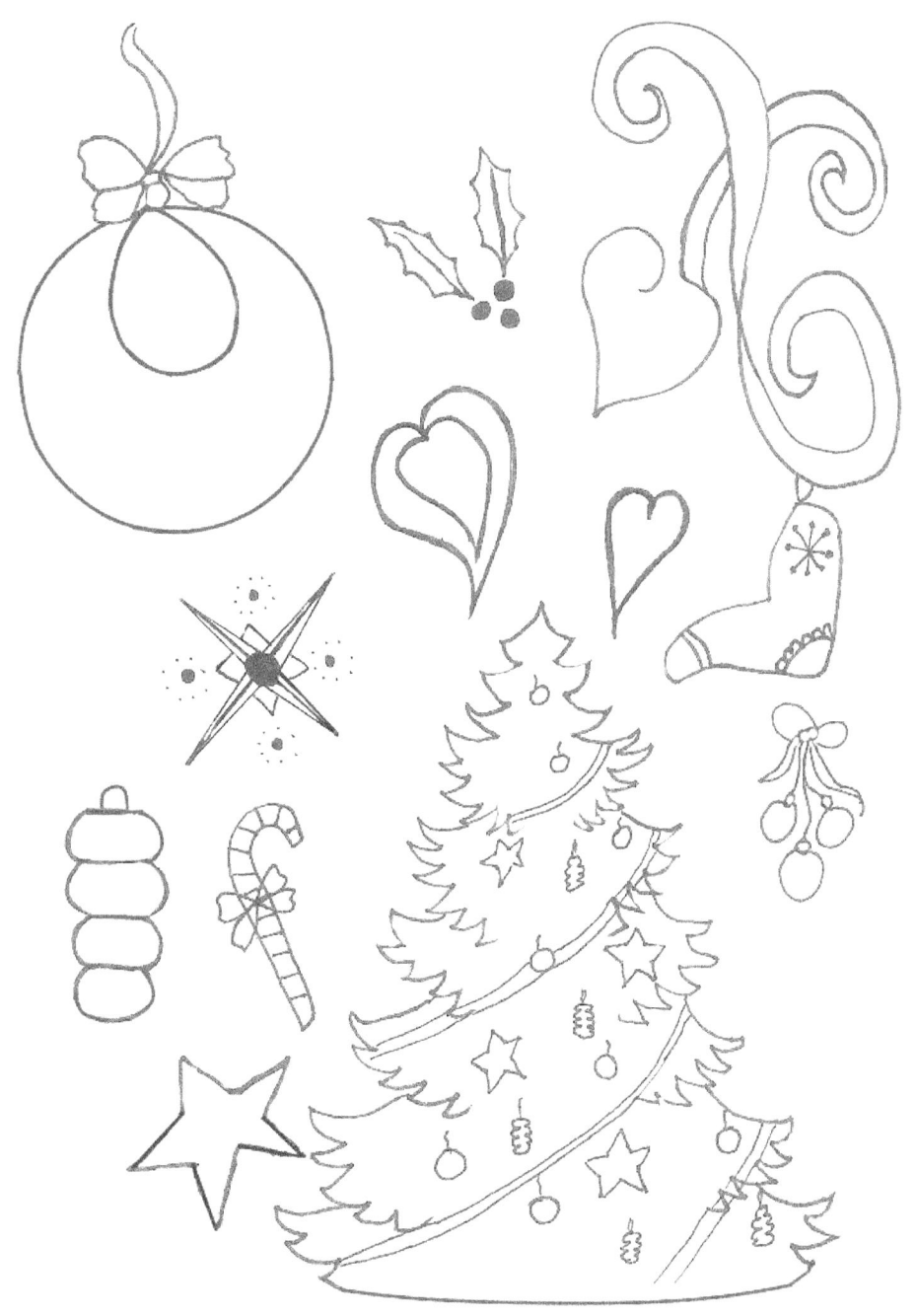

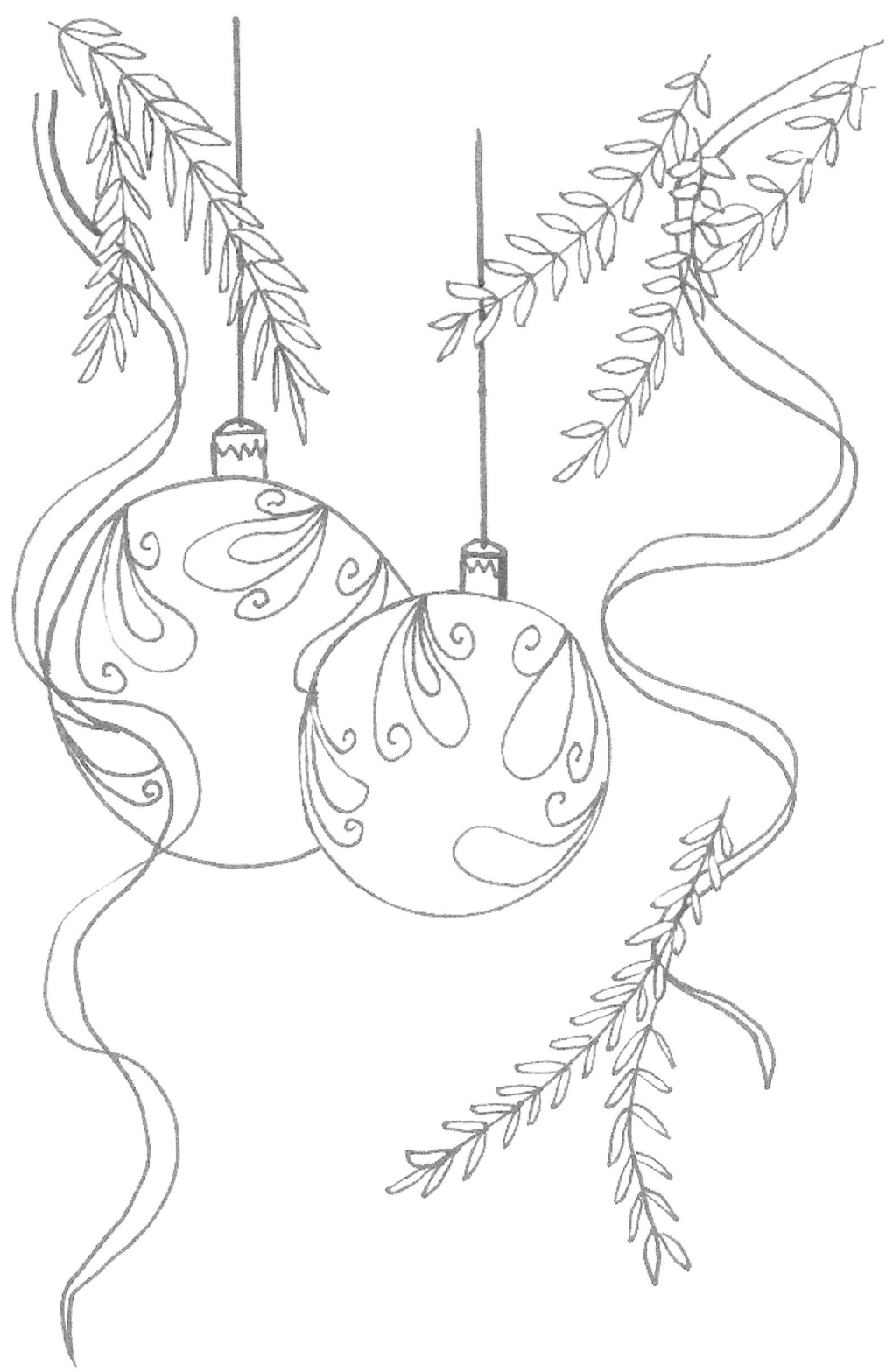

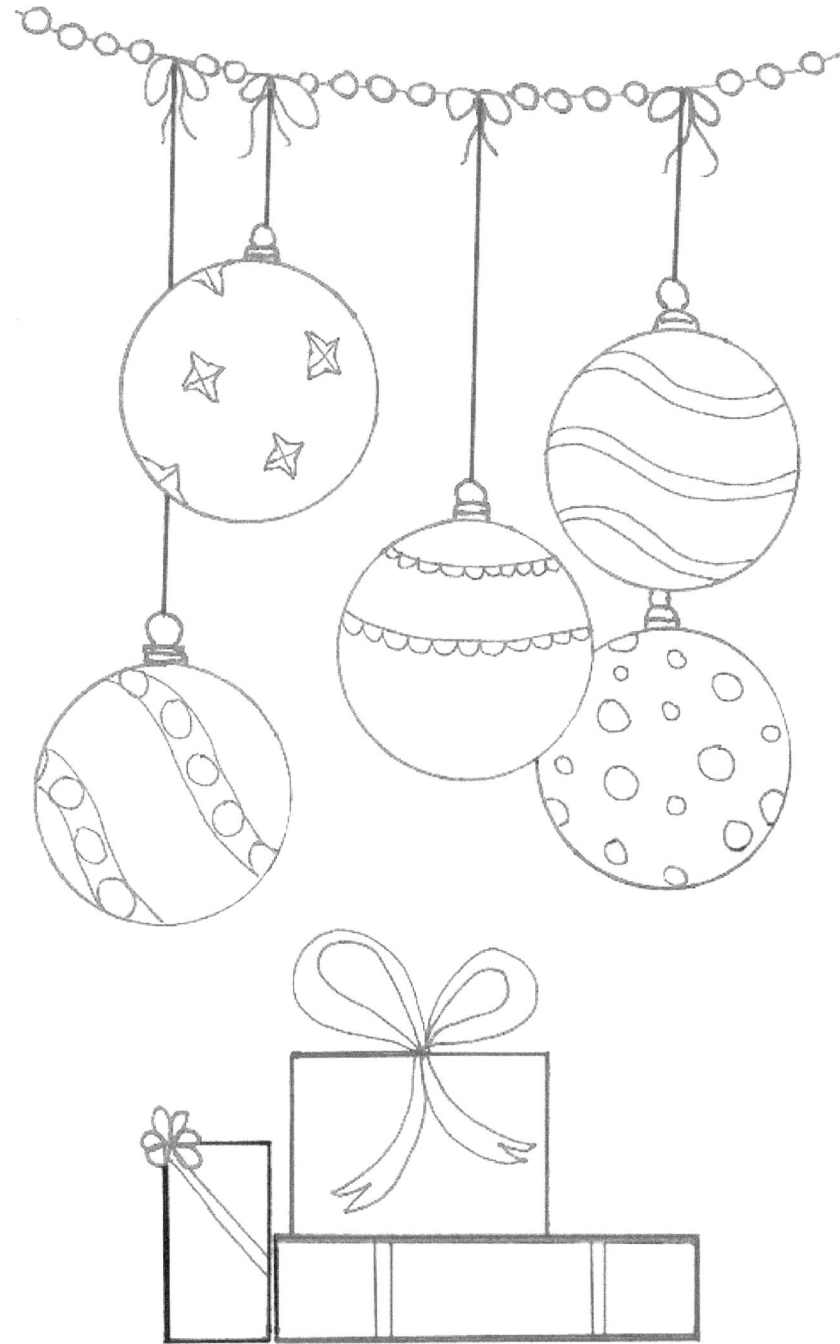

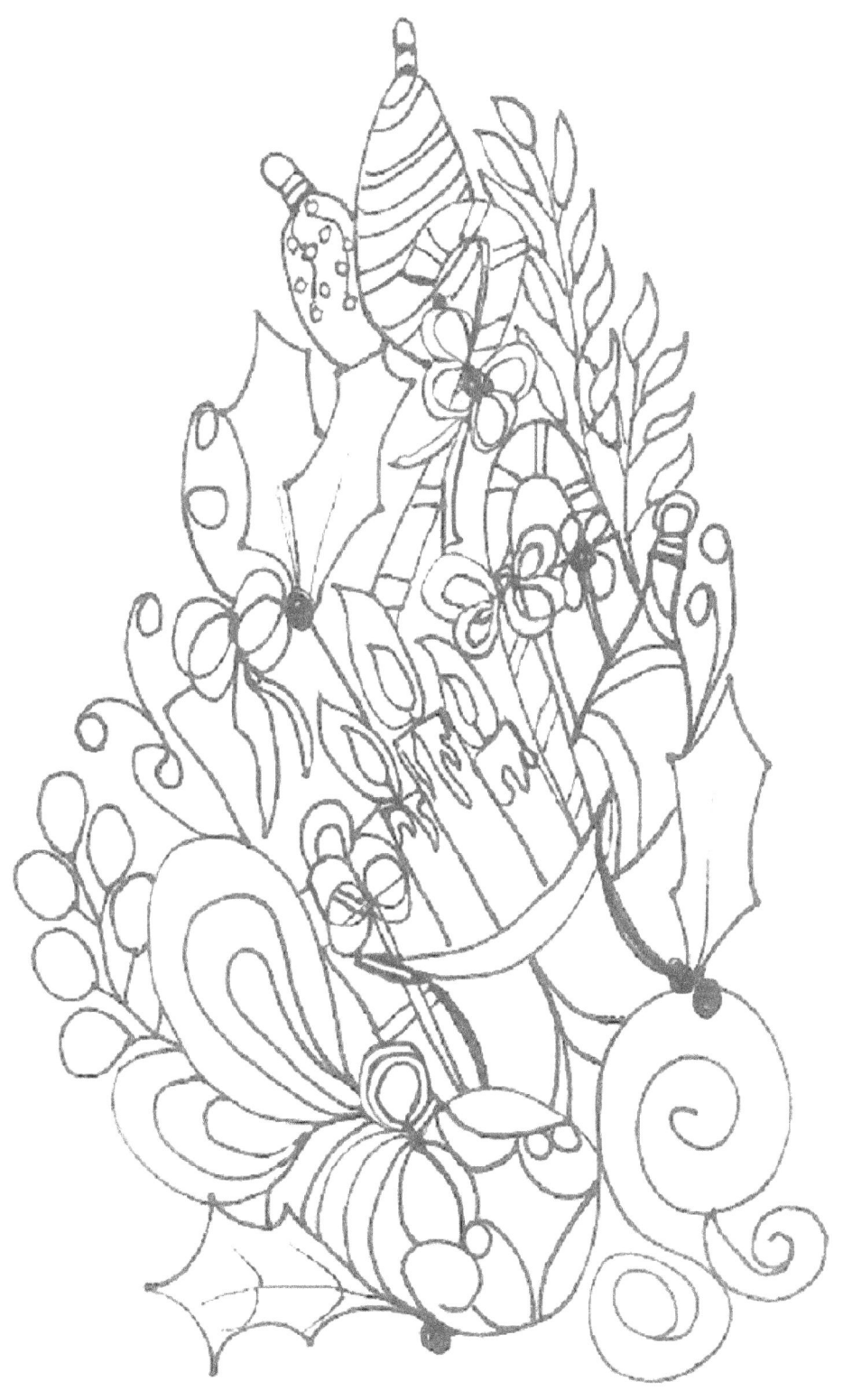

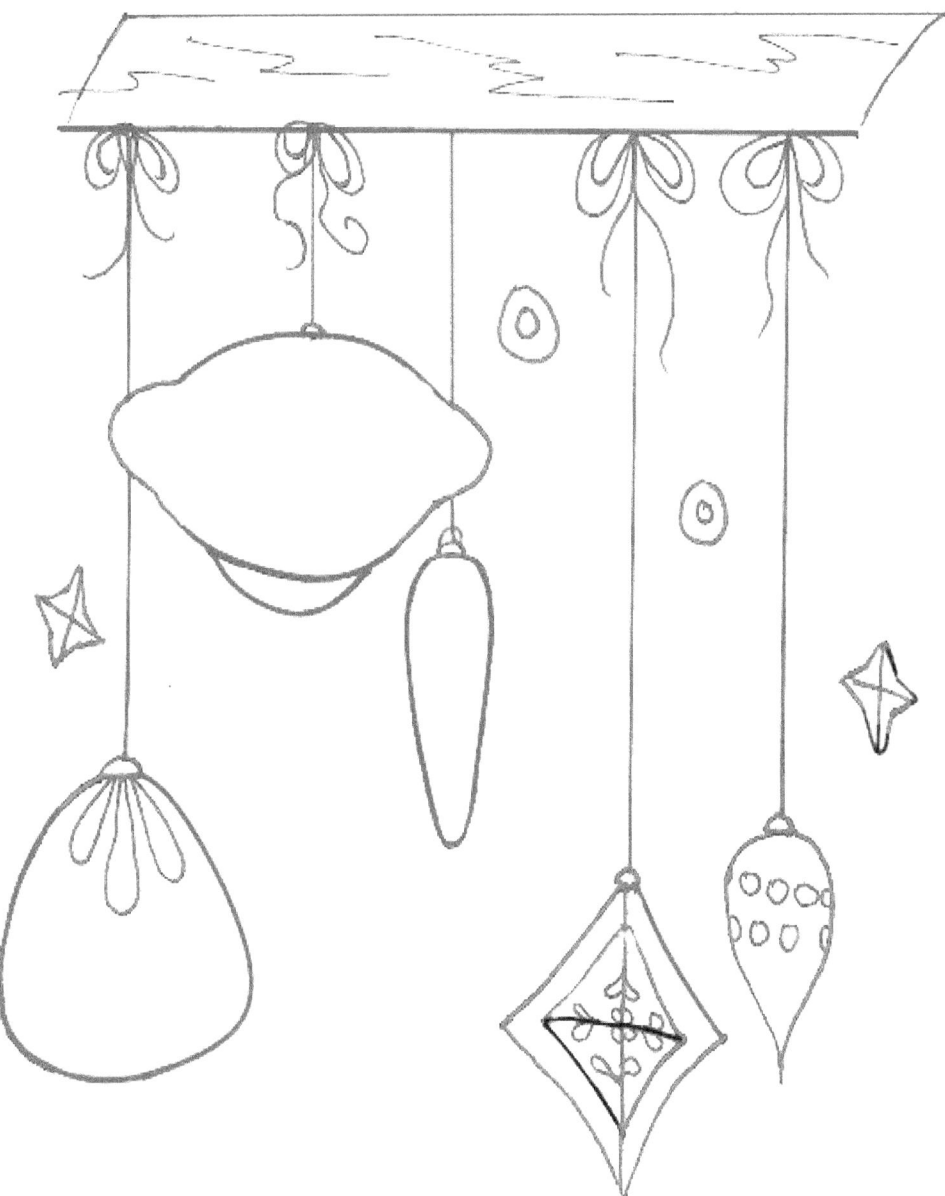

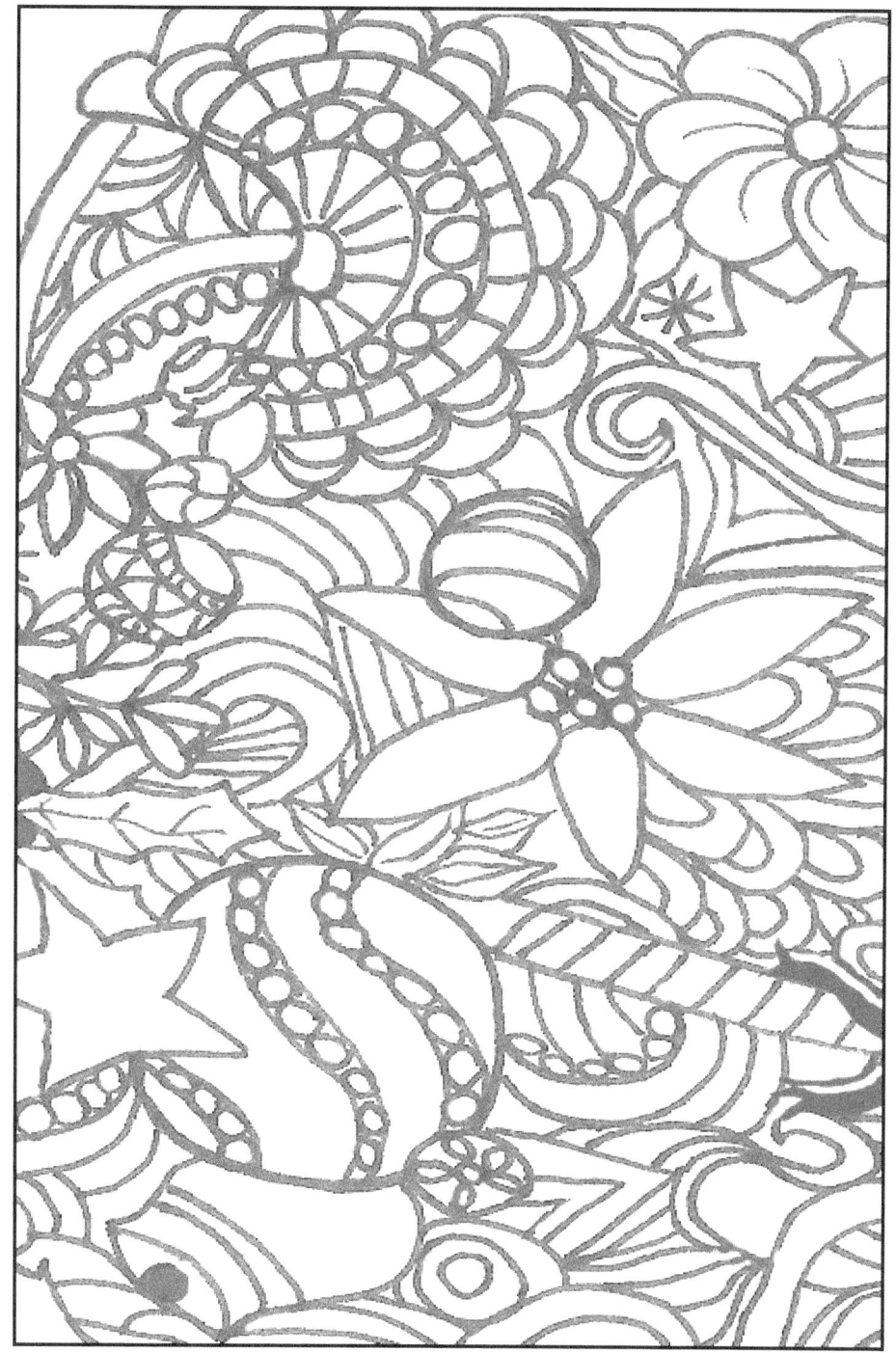

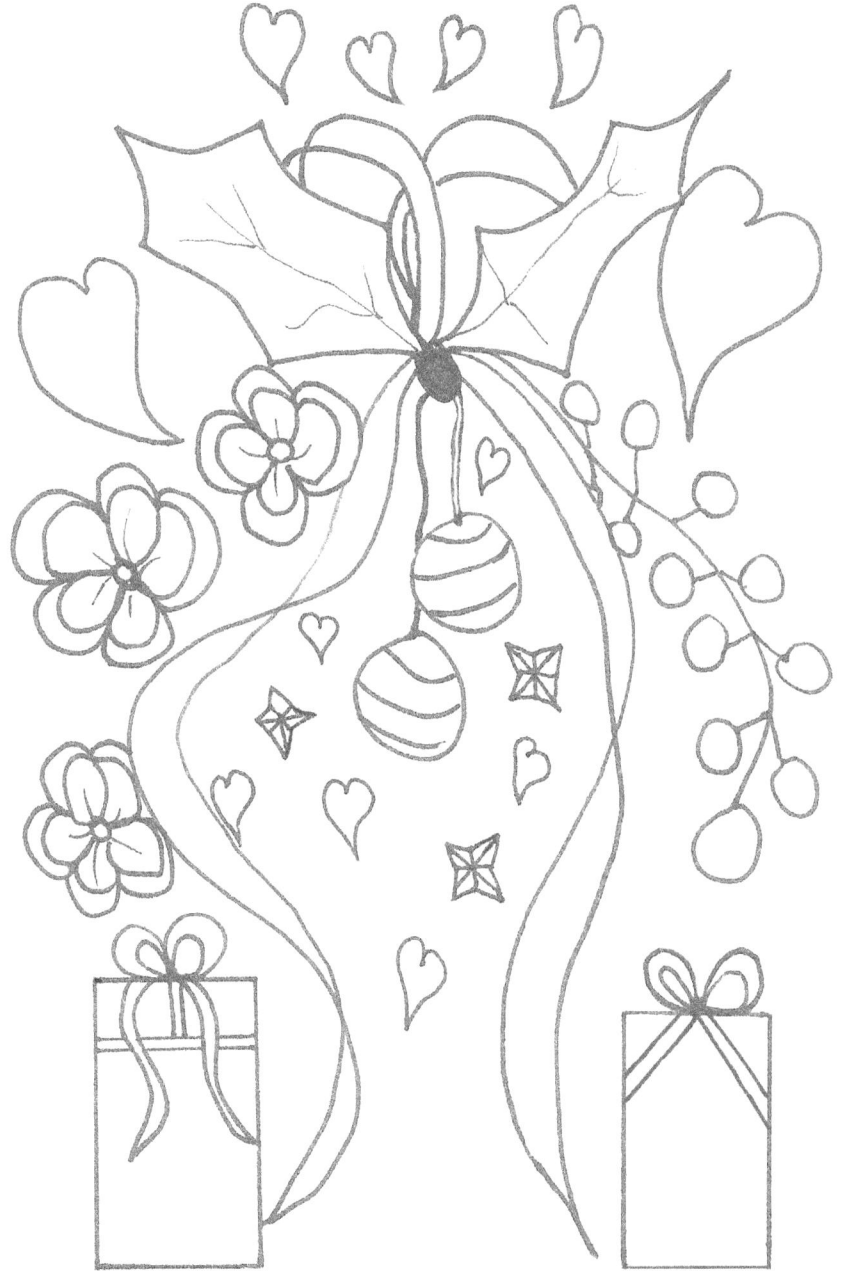

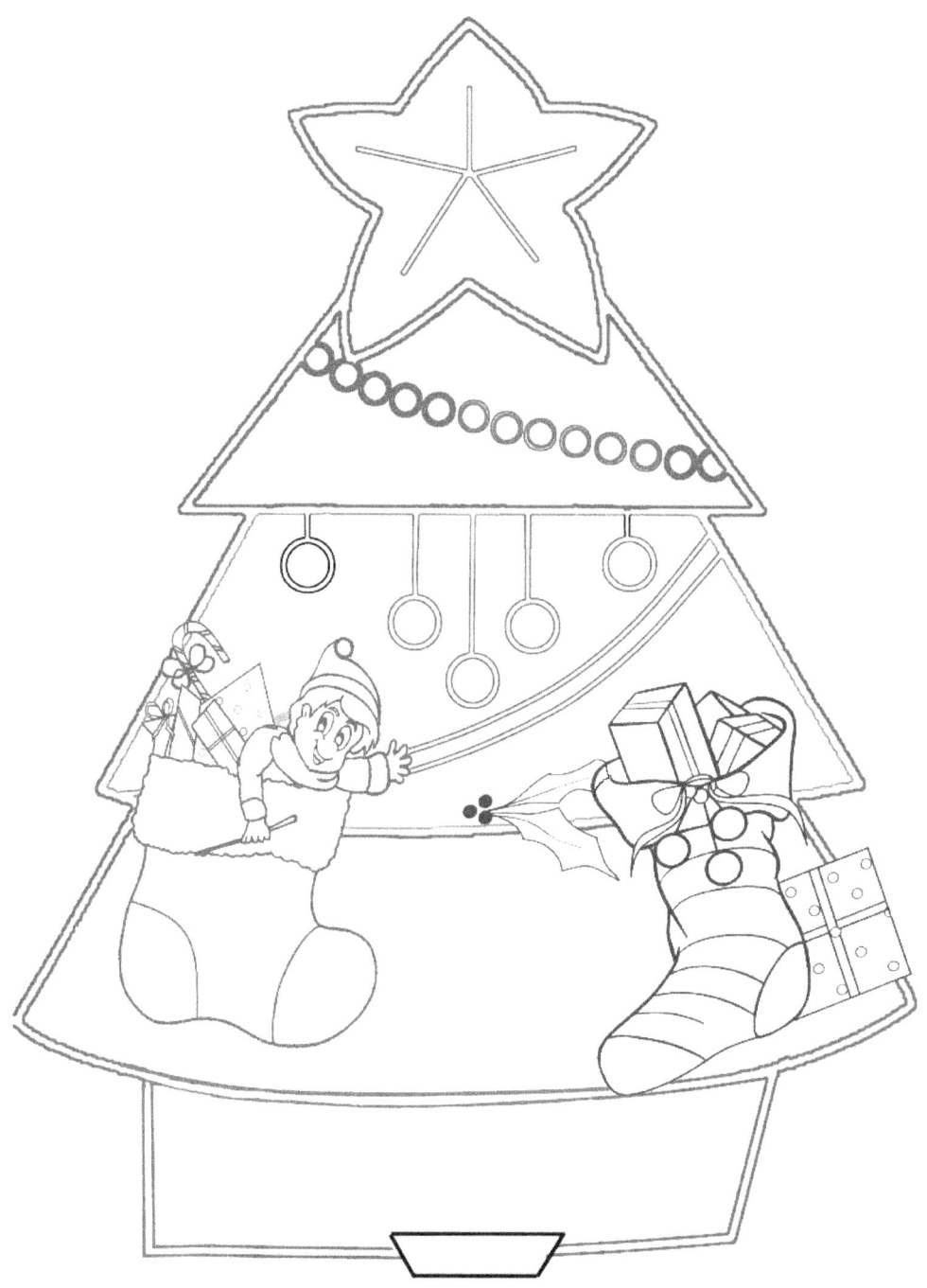

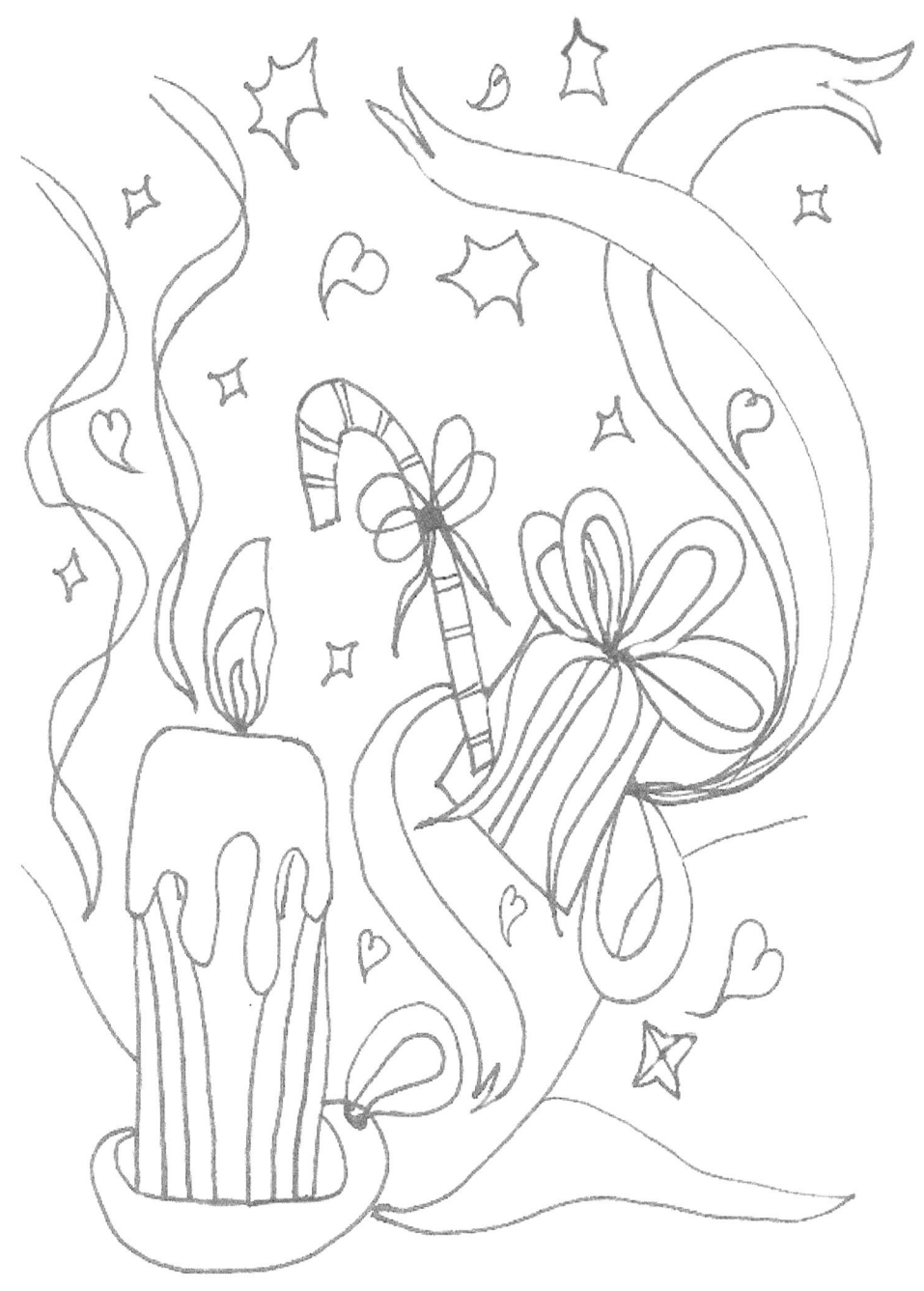

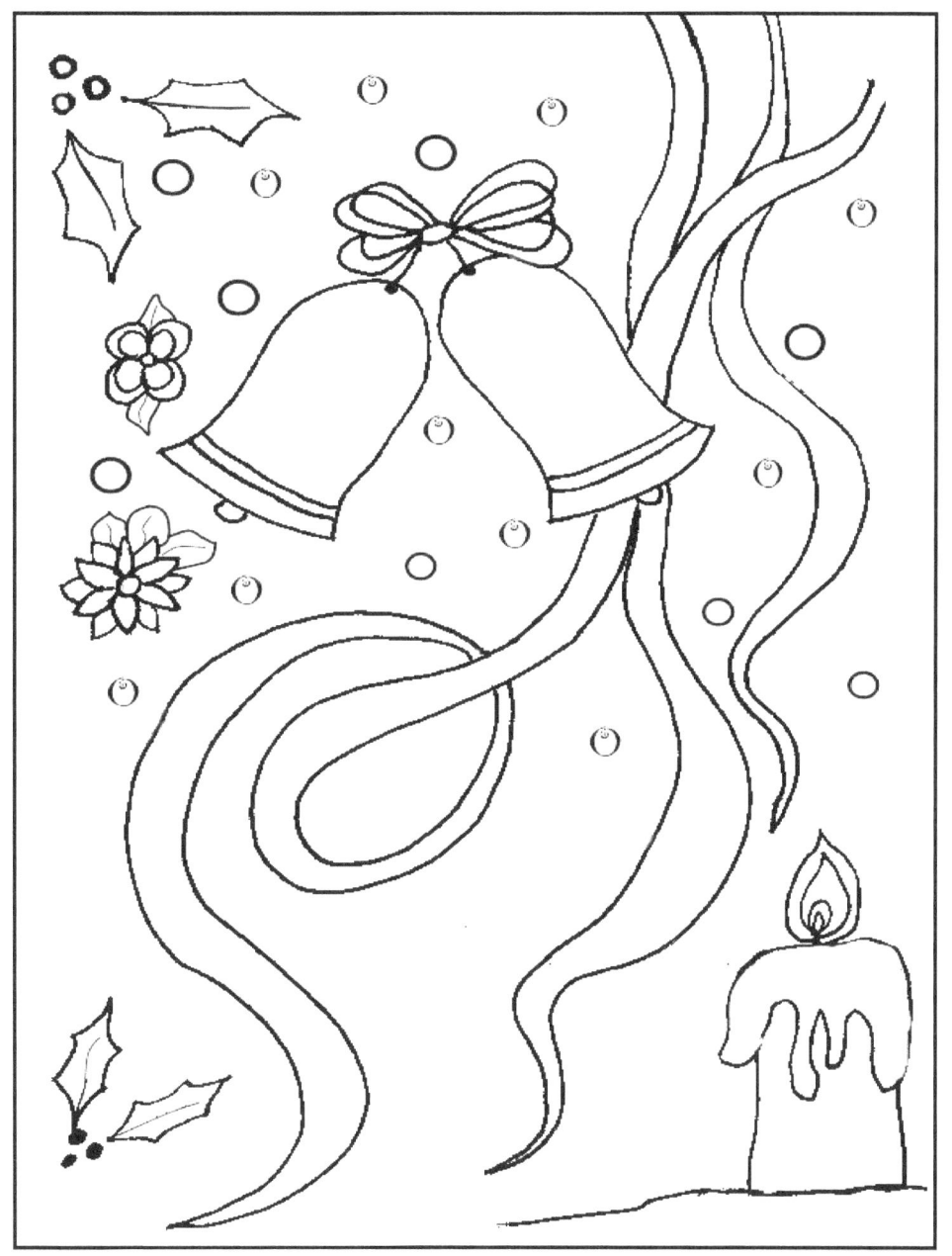

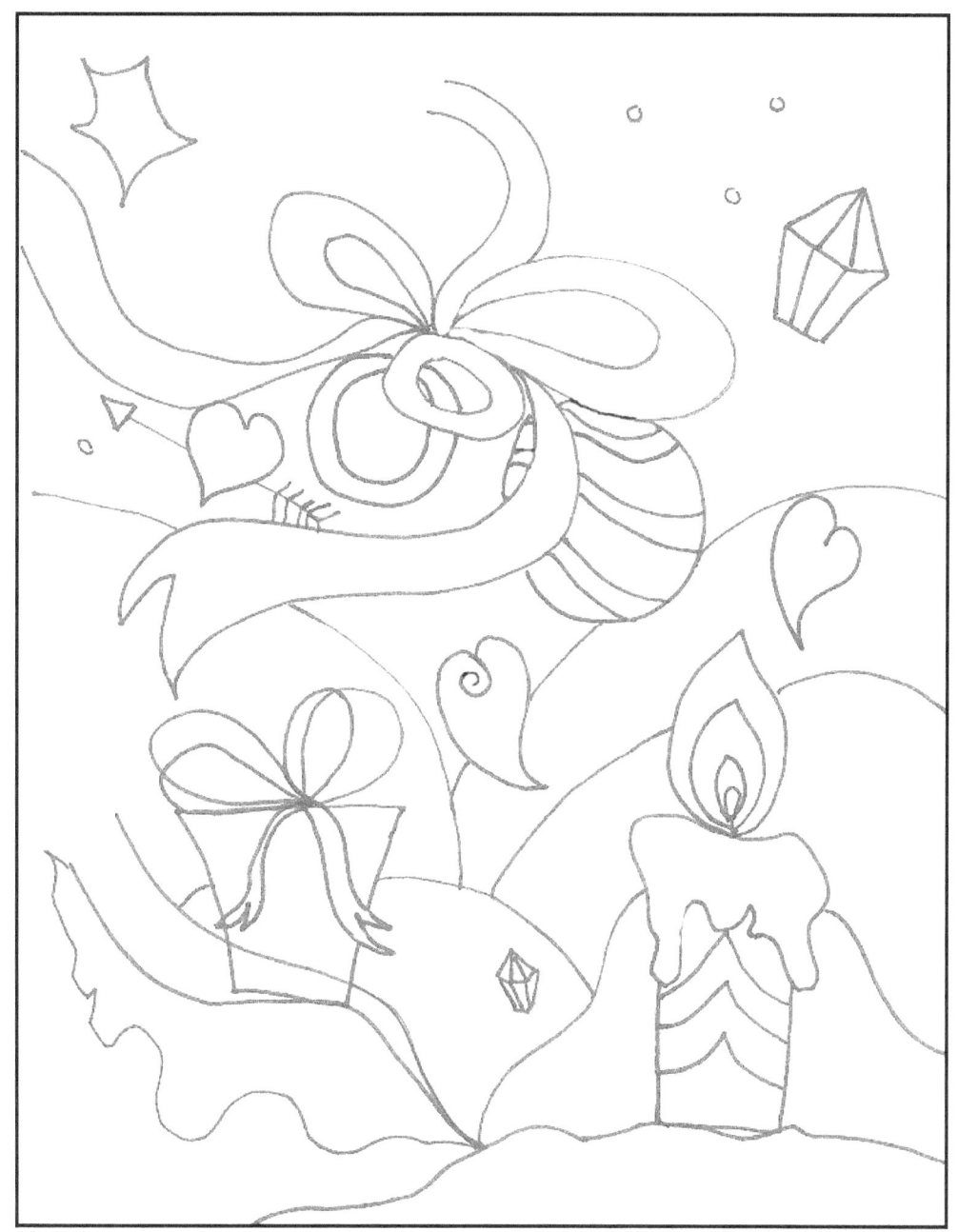

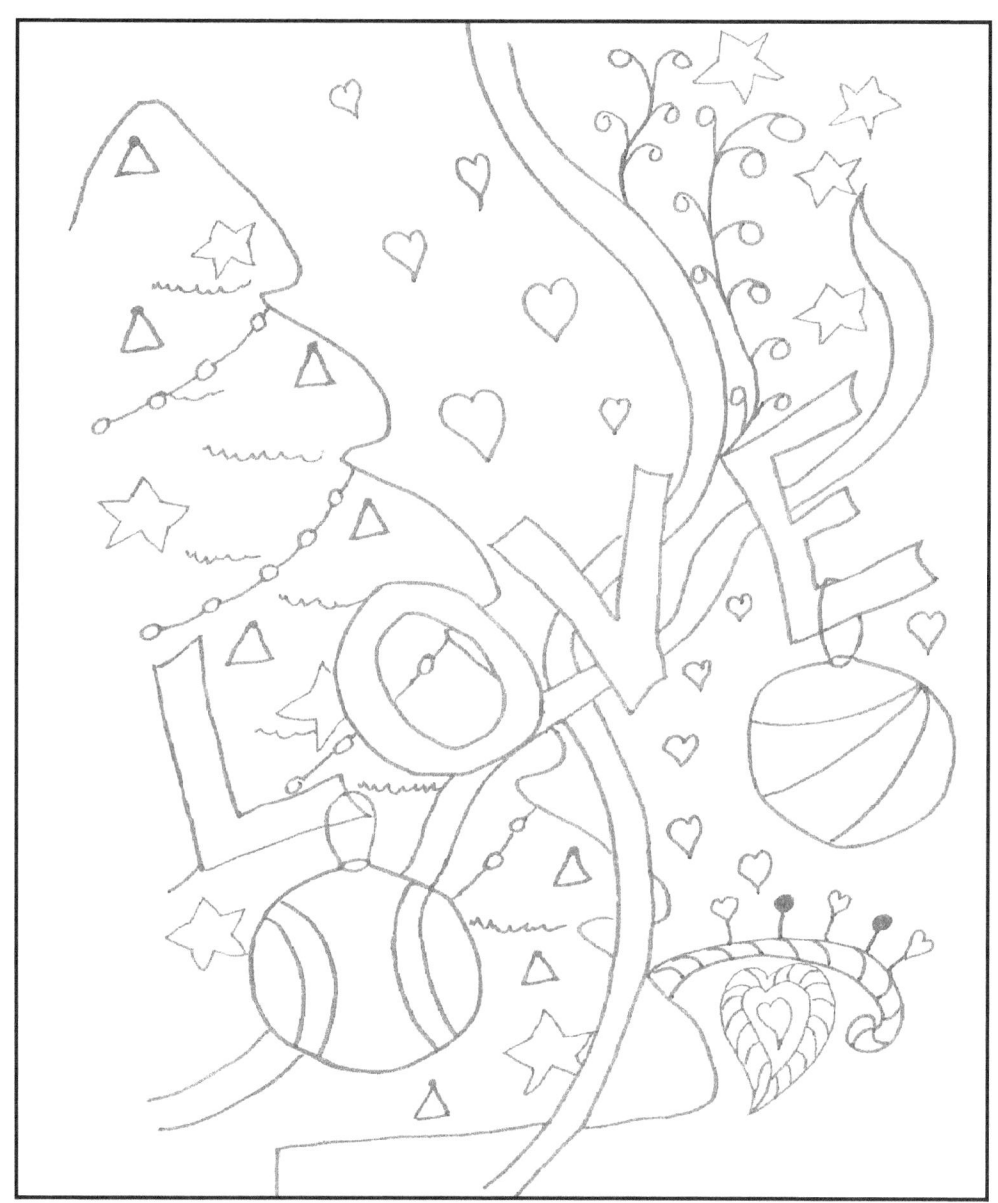

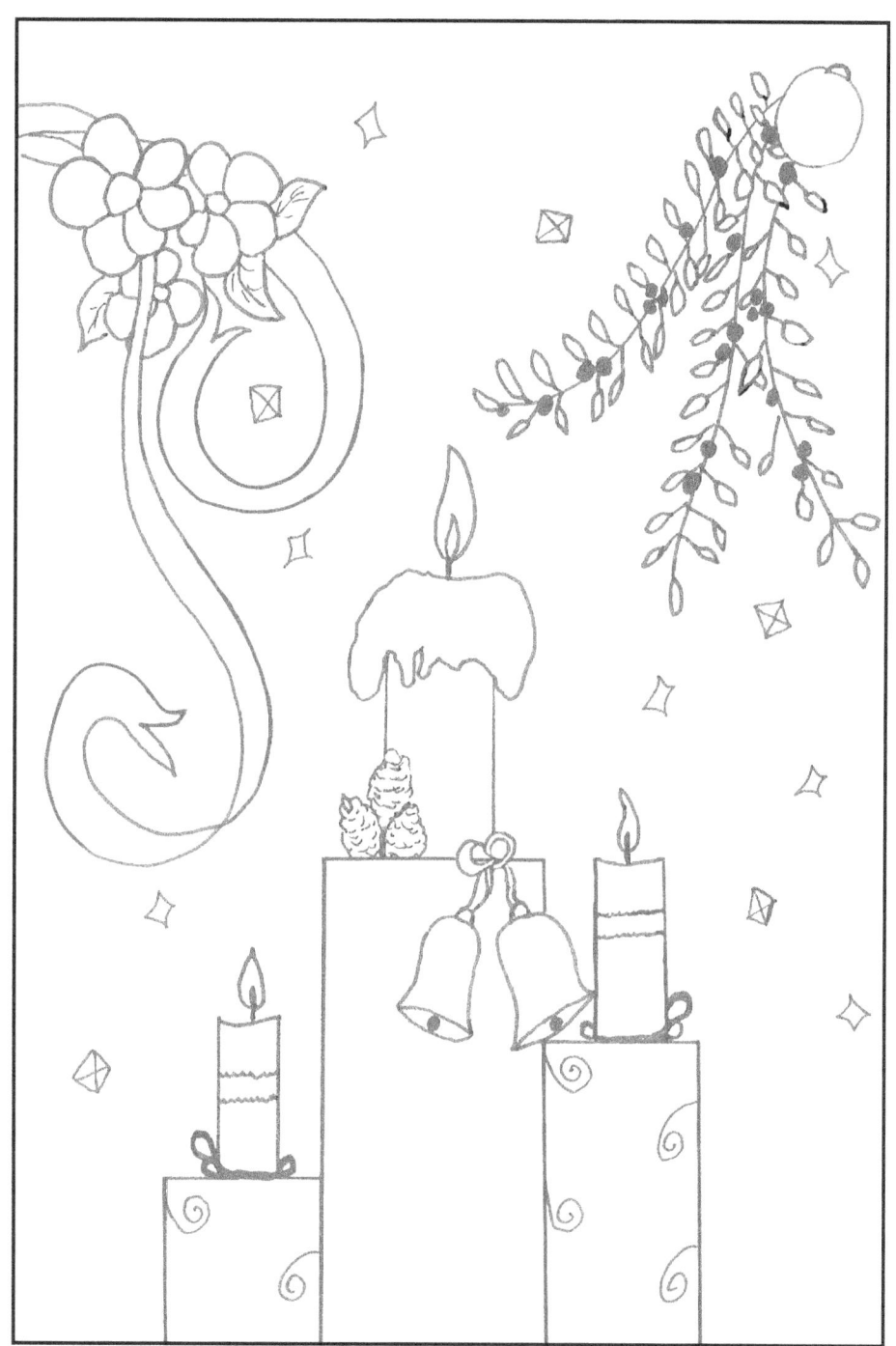

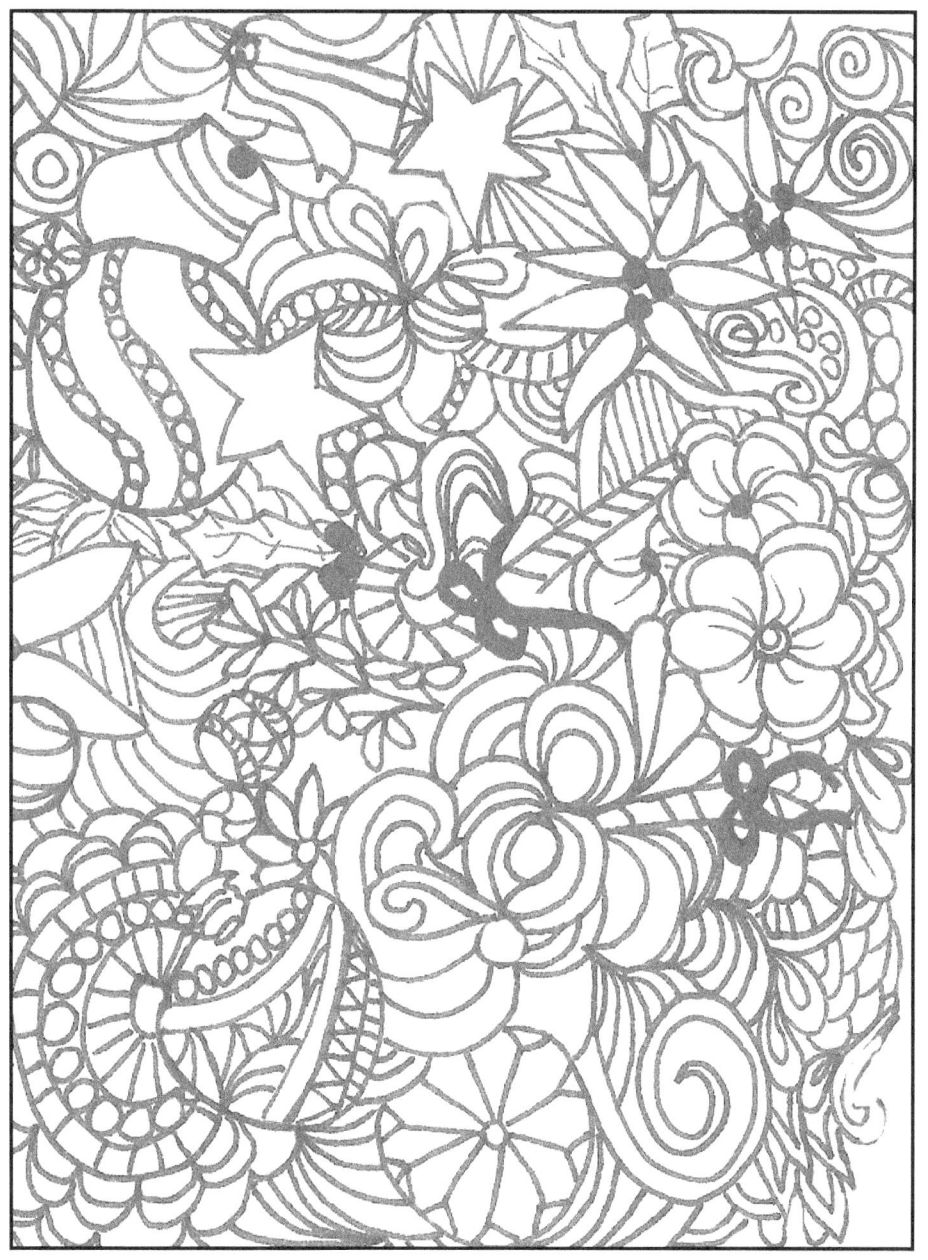

For more coloring and Puzzle books visit my author page at:

Kaye Dennan
www.CreateSpace.com

or CHECK OUT MY ACTIVITY WEBSITE:

http://www.wordsearchandpuzzles.com

I Hope You Have Enjoyed Using This Coloring Book As Much As I Have Enjoyed Putting Together These Drawings For You

www.ingramcontent.com/pod-product-compliance
Lightning Source LLC
Chambersburg PA
CBHW080541190526
45169CB00007B/2588